APERTURE MASTERS OF PHOTOGRAPHY

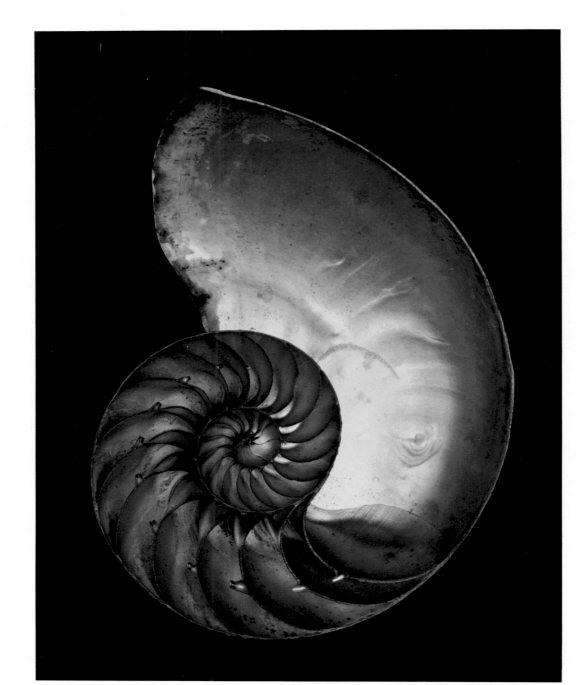

EDWARD WESTON

With an Essay by R. H. Cravens

APERTURE MASTERS OF PHOTOGRAPHY

NUMBER SEVEN

The Masters of Photography series is published by Aperture. *Edward Weston* is the seventh book in the series.

Copyright © 1988 Aperture. All rights reserved under International and Pan-American Copyright Conventions. Published in the United States by Aperture.

Manufactured in Hong Kong. Duotone film made in the U.S.A. by Robert Hennessy. Series design by Alan Richardson.

Library of Congress Catalog Number: 87-72059
First Hardcover Edition 1988
ISBN: 0-89381-304-4
First Paperback Edition 1988
ISBN: 0-89381-305-2

Aperture Foundation Inc. publishes a periodical, books, and portfolios of fine photography to communicate with serious photographers and creative people everywhere. A complete catalog is available upon request. Address: 20 East 23 Street, New York, New York, 10010.

EDWARD WESTON
by R.H. Cravens

Tucked into California's Big Sur coastline is a small cove where Nature has worked an infinitude of miracles. The panoramic eye views cliff plunging into sea, boulder-strewn shore, transient salt ponds, and a kaleidoscopic surf. Let the eye focus upon details near at hand, and the cove reveals a treasure of sculpted cypress root, ocean-carved rock, and an ever-shifting detritus of kelp, driftwood, and bone. The cove is Point Lobos. Its beauty, to even the casual onlooker, is mesmerizing. But if you have seen it through the eyes of Edward Weston—in the luminous masterpieces that he created with his bulky, sometimes recalcitrant, view camera—Point Lobos takes on a new, richer, even mystical, meaning.

Edward Weston was one of the true regenerative artists: an awakener of the eye and the evolving mind that it serves. Regeneration was a quality that Weston brought to photography for more than three decades, defining both the limits and the generosities of his medium. Point Lobos was only one of his subjects, though he returned to it again and again, and took his last photograph there. His career spanned crucial years in American photography, and restless pursuit of his art created a body of work that ranged over nudes, still lifes, industrial scenes, portraiture, landscapes, and any other subject that touched his visual imagination.

Weston's work alone would make him a formidable presence in the art of our century. But his legacy goes beyond the photographs. At the height of his creative powers, he poured his hopes, triumphs, follies, and despairs into a remarkable journal called the *Daybooks*. Few artists have left so vivid a record of their struggle to work, to love, and above all, to survive. And then there is the life itself—the third, expansive dimension of Weston's legacy. Recalled by friends, lovers, and sons, and searched out by a growing number of biographers, it is the life of a thoroughly American genius—courageous, pure, troubled, unorthodox, and utterly sure of its purpose.

Edward Weston was born in a Chicago suburb, Highland Park, on March 24, 1886. His father was a physician and a devoted archer. Of his mother, who died when he was five, Edward remembered little except the pain of her loss. Although his father remarried, Edward turned for maternal support to his sister, May, who was nine years older.

He was an under-sized, solitary, bad-tempered, and lonely child, who preferred hooky to school. In 1902, Edward's father sent a small Kodak box camera—a Bull's-Eye No. 2—to his son who was vacationing on a Michigan farm, together with detailed instructions and a caution not to waste film. Edward wrote back an enthusiastic letter de-

scribing his snapshots. Soon after his return to Chicago, the boy began saving money for a more ambitious 5 × 7-inch camera with a tripod. Many years later, he recalled his experiences with that second-hand camera:

> I needed no friends now . . . Sundays my camera and I would take long car-rides into the country—always alone, and nights were spent feverishly developing my plates in some makeshift darkroom.—and then the first print I made from my first 5 × 7 negative—a snow scene—the tightening—choking sensation in my throat—the blinding tears in my eyes when I realized that a "picture" had really been conceived—and how I danced for joy into my father's office . . . Months of happiness followed—interest was sustained—yes—without many lapses—is with me yet.

Despite a lifelong belief that "[school] is a good place to train and mold the minds of those who are to be the slaves of the world," Edward managed to graduate from the Oakland Grammar School in 1903. During the next three years, he continued to photograph, publishing an early submission, a landscape titled "Spring" in the magazine *Camera and Darkroom* in 1906. That same year he also traveled west to visit May, who had married and moved to Tropico (now Glendale), California.

Edward was ideally suited to California. Its climate, its landscape, its rambunctious energy, and—to no small extent—its eccentricities enticed him to stay. In the years that followed, he developed varying degrees of interest in astrology, the occult, nudism, vegetarianism, and virtually any other pursuit counter to prevailing orthodoxies. Yet, he kept himself a little detached, always veering away from dogmatic commitments.

With his decision to remain in California, Edward's first concern was earning a living. After brief stints working on field surveys and with the railroad, he resolved to become a photographer. At first, he worked door-to-door with a postcard camera—a forerunner of the modern Polaroid—that could in a few minutes develop small prints of families, children, or household pets. His transition to more serious commercial work, like most major changes in his life, was at least partly inspired by a woman.

Her name was Flora Chandler and she was the daughter of a wealthy land-owning family, an unlikely match for an itinerant photographer. Flora was not very impressed with the young Weston; he seems to have won her over with sheer persistence. He realized that, to support a wife, he would have to establish himself more seriously in his profession. Liking neither the place nor, particularly, the school, Edward returned to Chicago and spent several months studying at the Illinois College of Photography. There, he learned basic darkroom techniques and chemical formulas that changed little over the rest of his career.

Returning to California, Edward married Flora on January 30, 1909, and set out to create and support the kind of respectable, middle-class family he had been raised in. For the first year of his marriage, he took a couple of odd jobs, then settled in for a year working as a studio printer and retoucher. It was a job he hated. But in an article called "Shall I Turn Professional," published in *American*

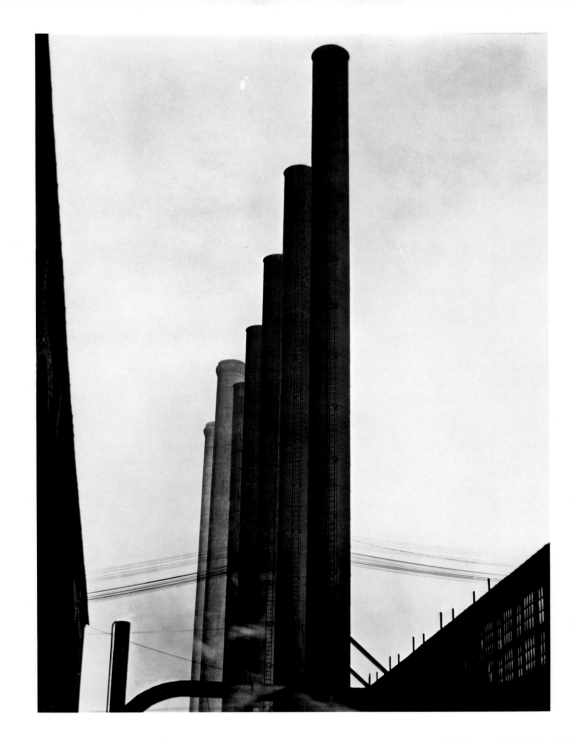

Photography in November, 1912, he urged a studio apprenticeship upon any hopeful amateur desiring to become a commercial success. In the article, he wrote of the need to turn out large batches of negatives, hundreds of prints uniform in tone, quality and depth. And he also invoked the necessity of making the weak subject look strong, the ugly appear beautiful. These were not transformations Edward admired: they were, however, the hallmarks of the money-making professional.

He opened his own studio in 1911, a sunlit shack that he built on a small piece of land Flora owned in Tropico. The next ten years were filled with hard work and commensurate growth—of his family, of his business, and increasingly, of his international stature as an artist.

The aesthetic creed during most of those years was Pictorialism, a movement founded during the 1890s in Europe that sought to elevate photography to the level of Art with a capital *A*. The stereotypical Pictorialist image was soft-focused, printed on highly textured matte paper, and imbued with the influence of impressionist painters, especially Whistler, and the compositional techniques of Japanese printmakers. The effect was painterly, often artfully prettified. Despite its rigid creed, Pictorialism generated masterpieces, many emerging from an American offshoot: the Photo-Secessionist movement founded by Alfred Stieglitz in 1902. Stieglitz asserted his purpose "to hold together those Americans devoted to pictorial photography in their endeavor to compel its recognition, not as the handmaiden of art, but as a distinctive medium of individual expression." The great exponents of Photo-Secessionism included Stieglitz, Edward Steichen, Clarence White, and Gertrude Kasebier.

Edward took his first photograph the year Photo-Secessionism was born, and in 1903 had visited—and was greatly impressed by—Stieglitz's curated exhibition at the Art Institute of Chicago. Ten years later, when he began his own career in earnest, Edward was isolated, far from salons and exhibitions in European and American art centers. He was, however, an avid reader and viewer of publications in which pictorial photography was beautifully reproduced, including *The Little Review* and Stieglitz's *Camera Work*. As Edward began the laborious process of printing and mailing his "personal" work to exhibitions and contests, he was well-versed in the regnant techniques and aesthetics.

Recognitions, awards, and honors came abundantly to the Tropico, California photographer. His submissions were primarily portraits and figure studies, distinguished by their original lighting, posing, and composition. The photographs were hung at exhibitions across the United States and in Canada, and won generous praise from reviewers. Edward's greatest triumph during this period occurred when five of his photographs were selected for the London Salon of 1914, whose Honorable Secretary, Bertram Parks, judged Weston's the finest group in a show that included virtually every major living photographer.

Such awards brought acclaim, but little in the way of cash. They did add to his local fame and helped bring paying customers to his Tropico studio. Edward needed the income. The first decade of his marriage had brought four sons—Chandler (1910), Brett (1911), Neil (1914), and Cole (1919).

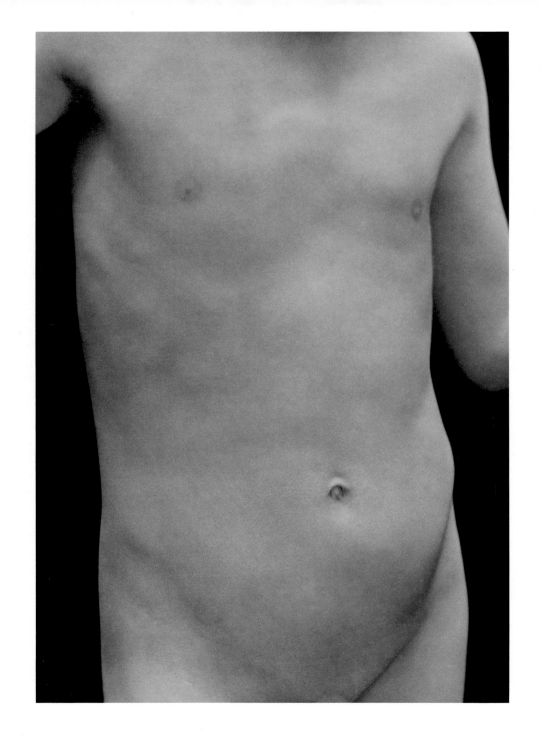

It was also a period when he grew increasingly frustrated with both his art and domesticity. The Weston facade of middle-class respectability began to crack like stucco on a California bungalow.

Many influences worked on Edward as he shrugged off the contemporary conventions. There was, for example, the California artist milieu, of which he was becoming an intrinsic part. In keeping with the "artiste" mode, Edward sported a flowing black cape, velvet jacket, floppy hat, and cane. Later, he admitted, the attire made him uncomfortable. More seriously, he decried many hypocrisies and philistine inanities in American middle-class values. Edward was also dissatisfied with his own work: through books and magazines he was aware of the revolutionary changes wrought by cubism, and its influence began to appear in Weston's composition. In 1915, Paul Strand began producing a body of work that helped sound the lingering death knell of Pictorialism and was memorialized in the final issue of Stieglitz's *Camera Work*. The next year, Edward stopped exhibiting and contributing to the salons, perhaps anticipating a new direction slowly taking shape in his photography. And, inevitably, there was a woman.

Her name was Margaret Mather, and she appeared on the scene as early as 1912. She was small, beautiful, and intelligent—an aesthete who sought the union of life and art as perfect experience. She first came to Edward to be photographed, then became, progressively, his pupil, model, and business partner. She resisted for years becoming Edward's lover, limiting their contact to the occasional passionate embrace. Edward appears to have been obsessed with her, although years passed before the obsession was consummated—and then, for a fling that lasted only a week.

As the twenties began, Edward met a woman far more influential in his life and work. Tina Modotti was an Italian-born, dark-haired, minor motion picture actress, with whom Edward apparently had his first, full-fledged adulterous affair. Tina became Edward's model and pupil, and a half-century later, her own photography found a large and well-deserved audience.

Tina went to Mexico in early 1922, taking with her a group of Edward's photographs. Exhibited at the Academia de Bellas Artes, they attracted the most enthusiastic response from the public the photographer had yet experienced. The strong reception in Mexico strengthened his desire to break with Tropico and Flora, and to work south of the border. First, however, he set out on a solitary trip to visit his sister and her husband in Ohio. There, he made the first of his industrial photographs. They were a stunning departure from his previous work: sharp-focused, powerful visions of the Armco Steel mills. Edward immediately recognized them as both "great photographs" and as the long-expected breakthrough.

The familial visit became a pilgrimage as Edward continued east to New York to meet Alfred Stieglitz. Edward had a mixed reaction to Stieglitz, just as Stieglitz had a mixed reaction to Edward's prints. Later, he would assess Stieglitz's comments as confirming the direction his work was taking, especially the Armco prints. Edward also met and exchanged viewings with the painter and photographer Charles Sheeler, Paul Strand, and others in the Stieglitz orbit. The New York visit, if not

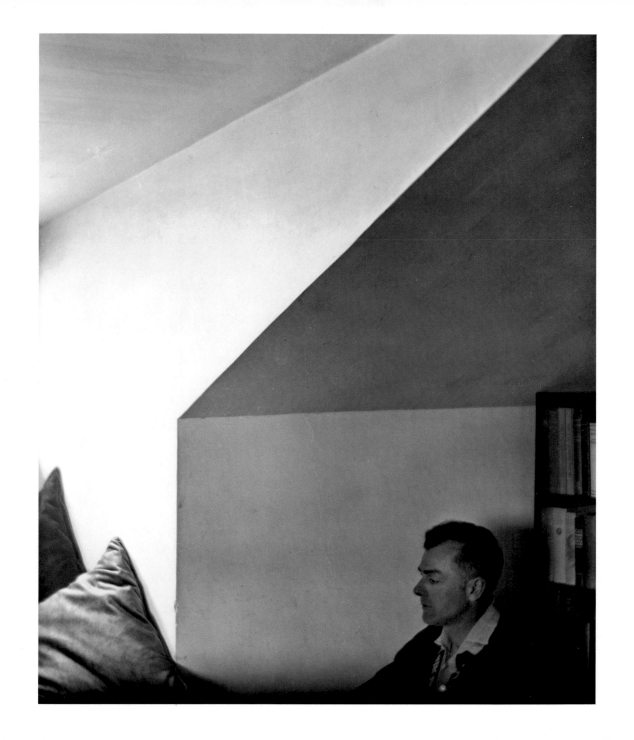

crucial to Edward's work, perhaps alleviated his sense of psychological distance from the East Coast center of photographic revolution.

In July 1923, he boarded a coastal steamer bound for Mazatlán, Mexico, accompanied by Tina and his oldest son, Chandler. Flora set him loose, though not without tears and recriminations, telling friends she knew Edward was a great man, that she should not hold him back. Yet, their marriage continued because of their sons, to whom Edward was a devoted if often absent father, and also because of Flora's seldom-failing financial support.

Edward arrived, aged thirty-seven, as the Mexican Renaissance was in flamboyant swing. Diego Rivera, José Orozco, and other leaders of the Mexican movement immediately embraced the California photographer and lavished him with praise. After one exhibit, a press reviewer described him as "Weston the Emperor of Photography." In turn, Mexico both dazzled and saddened Edward. He became an *aficionado* of the bullfights, describing the *corrida* as "the most electrifying, stupendous pageant of my life." In the midst of the country's poverty and an ongoing revolution he also wrote of seeing "faces to freeze one's blood, so cruel, so savage, so capable of any crime." "Yet," he added in an aside that is pure Weston, "the Mexican bandit may be preferable, and at least more picturesque, than certain sleek American businessmen."

Edward and Tina dived into the riotous party-life of Mexico. There, as elsewhere, Edward preferred costume parties, at which he appeared in high drag. Often, to his delight, he was so successful at female impersonations that guests were alarmed to discover that he was indeed a man. He was considered expert at the tango and rhumba, and would happily dance through the night. Artistically, the Mexican sojourn was the period of some of Weston's greatest portraits, including those of Tina, General Galvan, Lupe, Rivera's wife—and what became the standard portrait of D. H. Lawrence.

Edward's exuberance alternated with bouts of depression, usually because he was broke. He also felt keenly the distance from his sons, and the fact that he was dependant upon Flora for the desperately needed remittances.

His swings of mood may have led him to engage more fully in his journal-writing. He burnt all but a few pages of his pre-Mexican diaries, but left an intimate record of his life for the next ten years. At the outset of this autobiographical flow, he was self-conscious:

> I am sure . . . that my diary is a safety valve for releasing corked-up passions which might otherwise explode—though I sometimes think storm clouds would sooner break with a thunder of words,—but a perspective of months must bring a saner, less hysterical, more genuine outlook.

It was precisely the emotional storms that often generated Edward's energetic, fascinating descriptions of bullfights, parties, love affairs, and the constant visual onslaught that stimulated his work. He is also generous in these journal pages with the inner life. One entry records a dream, perhaps a symptom of resentment left over from his session with Stieglitz:

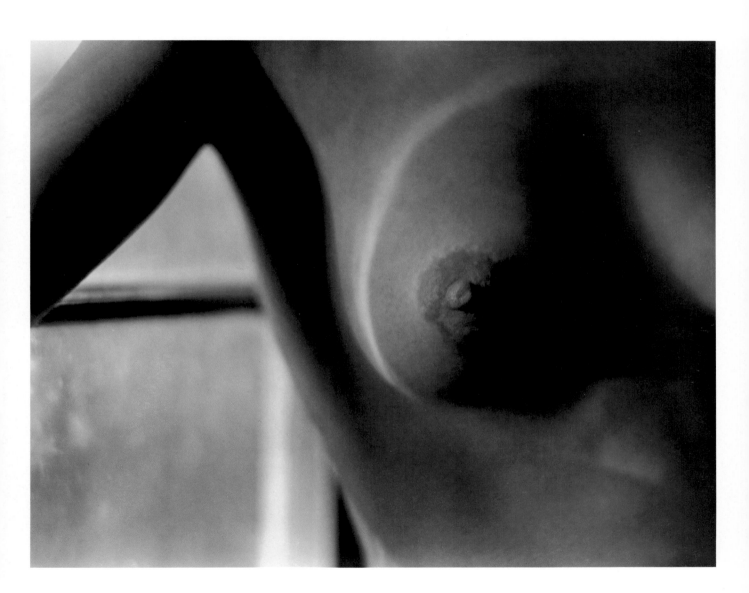

May 24. If dreams have any symbolic significance, the one I had last night remains of great import. I only have a thread to go on. Someone . . . said to me . . . "Alfred Stieglitz is dead." "Alfred Stieglitz is dead!" I exclaimed. "No," said the person, referring to a newspaper, "not dead but dying."
The obvious way to interpret the dream . . . would be in the forecast of a radical change in my photographic viewpoint, a gradual "dying" of my present attitude, for Stieglitz has most assuredly been a symbol for an ideal in photography towards which I have worked in recent years.

After eighteen months, and several postponements and hesitations, Edward and Chandler went back to Glendale. Almost immediately, Edward made plans to return to Mexico. Flora had moved into her parents' home; relations with her were polite, strained. He was under severe financial pressure, and also emotionally unable to settle back into California life. Once again involved with sons and friends—as well as a new love named Miriam Lerner—Edward revealed deepening conflicts and melancholy in his diaries. In San Francisco he wrote:

One does not necessarily act for the best—nor even nobly, in destroying personal aspiration for the sake of others—the greatest if less apparent gain—even for those others—must come from the fulfilling of one's predilections rather than in sentimental sacrifice. Yet I realize that I face sacrifice, no matter what the decision.

Astonishingly, the emotional storms did not interfere with a flow of magnificent work. He photographed nudes of Miriam and Neil, boats anchored near San Francisco, a friend caught in the grip of mental illness, and street scenes near his studio. He also had a successful exhibition at the Japanese Club in Los Angeles. "In the three days," he wrote, "I sold prints to the amount of $140.00— American Clubwomen bought in two weeks $00.00—Japanese men in three days bought $140.00 . . . what a relief to show before a group of intelligent men!"

Eight months after his return, Edward again departed for Mexico, this time taking Brett with him, and reestablished domestic life with Tina. And again, Mexico inspired his photography. Invoking a favorite quote, "form follows function," he delighted in making a series of photographs, both impish and masterly, of a toilet. Yet, he was disturbed that year with studies in form—particularly a group of nudes—that appeared to be taking him toward abstraction, which previously he had felt antipathetic to the true purposes of photography.

Edward invariably refused to be bound by dogma, even of his own devising. He had noted before that his photography was always several jumps ahead of his thoughts about it. As he later wrote to Ansel Adams:

I am not limiting myself to theories, so I never question the rightness to my approach. If I am interested, amazed, stimulated to work, that is sufficient reason to thank the Gods, and go ahead! Dare to be irrational!—keep free from formulas, open to any fresh impulse, fluid.

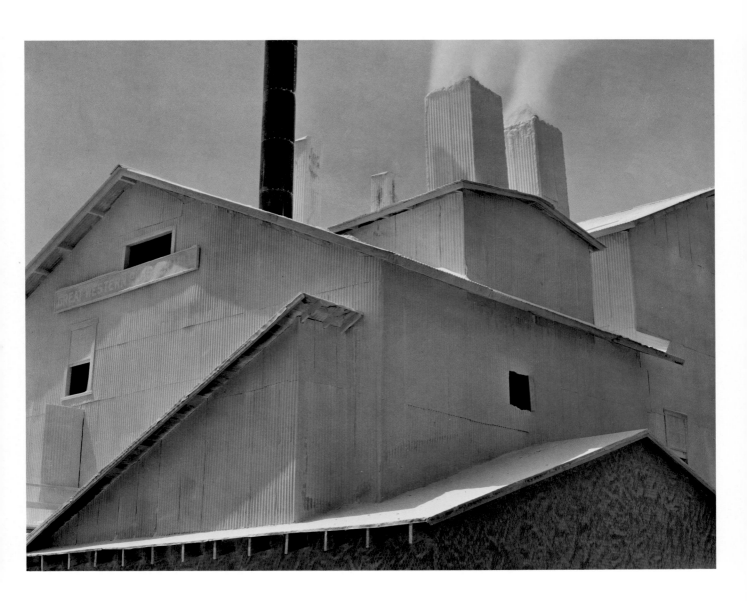

Late in 1926, when Edward and Brett left Mexico, the photographer was acutely aware that he was saying a final farewell to the country and to Tina. Back in California, he resumed work in the studio, and took up, at least part time, his domestic life with Flora and his sons. He also resumed his extramarital affairs. Women were drawn to him in such numbers that he exclaimed in his *Daybooks*: "Why this tide of women!"

In 1927, Edward's photography entered new realms of discovery. While visiting a painter friend, Henrietta Shore, he became entranced with a group of shells. He took these chambered nautiluses back to his studio, and began making lengthy exposures, experimenting with every conceivable combination of arrangement, lighting, and backdrop. The shell prints emerged with a power of form and a mysterious inner life that set them apart from any still lifes previously accomplished in photography. In the years that followed, he worked the same transformations with peppers, shard, roots, and other vegetables. Edward recognized that these photographs fulfilled his ideals. Of the famous Pepper No. 30, he wrote:

It is classic, completely satisfying—a pepper—but more than a pepper: abstract, in that it is completely outside subject matter. It has no psychological attributes, no human emotions are aroused: this new pepper takes one beyond the world we know in the conscious mind. To be sure much of my work has this quality . . . take one into an inner reality—the absolute—with a clear understanding, a mystic revealment.

He completed this *Daybook* observation with a statement of his enduring goal in photography:

the "significant presentation" . . . the presentation through one's intuitive self, seeing "through one's eyes, not with them"; the visionary.

The still lifes ushered in what a statesman's biographer might call "the years of triumph." The thirties brought Edward a succession of artistic breakthroughs; new and often more fulfilling relations with his growing sons, and the greatest love of his life. Everything came to Edward in those years except, inevitably it seems, enough money to keep persistent anxieties at bay.

Early in the thirties, Edward began to explore the riches of California's Big Sur coast, especially the Point Lobos cove near Carmel where he had settled. At first, his camera focused on the close at hand, as in a brilliant series of cypress roots, curved and etched, as he described them, "like flames." Gradually, his visionary penetration extended to the broader scale of landscapes and coastal studies. This, too, was a breakthrough. Early in his career, Edward had expressed doubt about the possibilities of photographing landscapes with the mastery a great painter might achieve. Vistas of unmanipulated Nature seemed too chaotic. As one critic observed, Edward's Mexican landscapes, lacking horizons, appeared more like large outdoor rooms. Big Sur and the deserts and dunes of California unleashed his ability to extract masterpieces of form and beauty from the limitless.

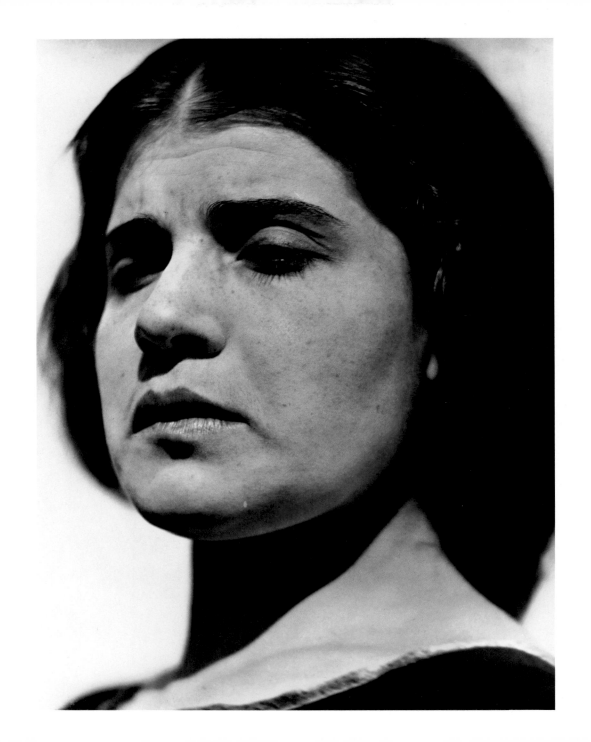

He had, of course, resumed exhibiting, and found himself more and more in the role of guru—an unwilling if usually gentle one—to a new generation of photographers. They included gifted pupils, such as Willard Van Dyke. It was Van Dyke who masterminded the *f*/64 Group, which included among others Weston, Van Dyke, Imogen Cunningham, and a new and valued friend, Ansel Adams. They were brought together largely by Edward's theory that sharp-focused, pure photography served as the necessary antidote to the remnant Pictorialists. At the heart of this theory was Edward's criterion of previsualization: that the printed image was fully realized the moment the shutter snapped. This did not mean—at least for Edward—that the darkroom was not a place of considerable manipulation to achieve the image the mind had envisioned. Typically, Edward kept his ties to the group loose: creed was, as ever, anathema.

Another original member of *f*/64 was a gentle, devoted student of photography, Sonya Noskowiak. Edward's pupil and mistress beginning in mid-1929, she lived with him for five years. Sonya brought a new quietness and stability to Edward's life and, apart from a few lapses, he was faithful to her. It was Sonya who brought many of the peppers, artichokes, and shards into the studio for Edward's still life studies. Sonya also helped recruit nude models, including a beautiful young poet named Charis Wilson.

Many years later, Charis recalled her first impression of Edward when they were introduced in a Carmel gallery:

Across the room stood a short man, very lean and erect, with a horn-rimmed pince-nez hooked to the lapel of his brown corduroy jacket. His deeply tanned face matched his clothes, and his reddish brown hair receded to expose a big dome of a forehead. His large, intense brown eyes held a playfully wicked gleam as they glanced over me. For anyone interested in statistic—I wasn't—he was 48 years old and I had just turned 20. What was important to me was the sight of someone who quite evidently was twice as alive as anyone else in the room, and whose eyes most likely saw twice as much as anyone else's did.

Charis insightfully probed Edward's success both in photographing nudes and captivating his subjects:

Edward made a model feel totally aware of herself. It was beyond exhibitionism or narcism; it was more like a state of induced hypnosis, or of meditation. Curiously, he could do much the same thing without a camera . . . When he turned that vitality and receptiveness upon a woman, he made her feel more completely *there* than she probably had ever felt in her life.

Edward and Charis met secretly at first to spare Sonya's feelings, but the attraction was too strong. In 1934, they moved in together. Five years later they set up their true home: a small, pristine house built by Edward's son Neil, who had become a master woodworker, on Wildcat Hill near Carmel.

Wildcat Hill represented nearly everything Edward had sought as a design for living. There was a large, open room, sparsely but comfortably furnished, with a huge fireplace, and a darkroom. Windows looked out upon the Pacific Ocean. Sur-

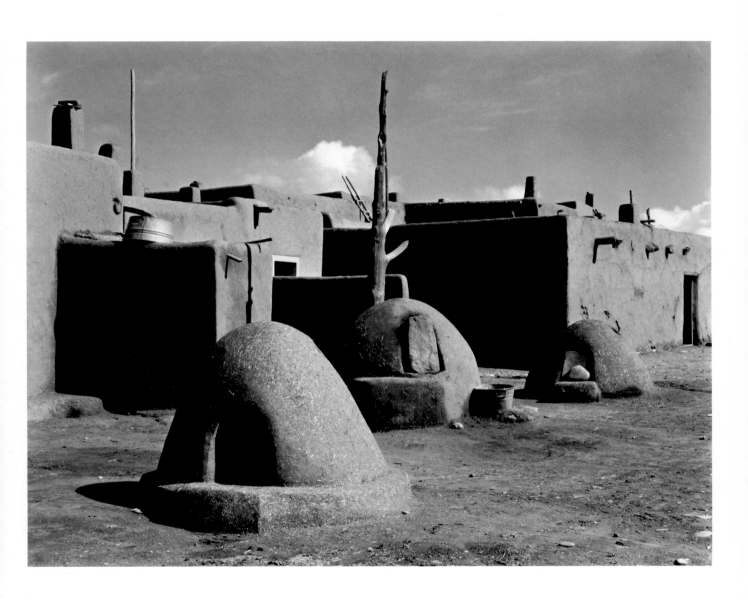

rounding the house were gardens, and within and without there was a growing population of cats. The daily routine was simple and orderly, with meals caught on the run and the hours cleared for Edward's photography and Charis's writing. Evening was often time for guests such as Adams, the poet Robinson Jeffers, the writer Lincoln Steffens, and others in Weston's circle of artists and friends. Intense discussions about art, with Edward's beloved Bach recordings playing in the background, alternated with dancing parties.

It was a rich, full life on Wildcat Hill, but it would be a mistake to judge it as an idyll. The Depression brought him even deeper financial troubles, and Edward's descriptions of dealing with one crisis after another suggest the breathless relief of a mouse barely escaping the snapping trap. Then, too, his sons were grown and often in residence. For all the affection between them and Charis, she was having to share Edward with this boisterous brood of her own peers.

As before, Edward's work progressed and grew. His *Daybook* entries dwindled, then stopped. Charis assumed the greater burden in helping with articles and other writings to accompany his photographs. She continued to inspire what he considered his finest nudes, especially a breathtaking series photographed on the dunes near Oceano, California. It was also Charis who urged him to apply for the first Guggenheim Fellowship ever awarded to a photographer.

The Guggenheim project, which began in 1937, was ultimately a two-year journey across California and into neighboring states. Charis drove most of the thousands of miles (Edward never learned to drive and was always dependent for transportation upon sons, lovers, or friends) and wrote a colorful, delightful account of their adventures. At the zenith of his powers, Edward exposed more than 1,500 negatives. Edward's photographs and Charis's text resulted in the book *California and the West*. Their collaboration had evolved on another level. Weston, who had at long last divorced Flora, married Charis during the Guggenheim travels.

The warm critical response to *California and the West* led to a commission from the Limited Editions Club for Edward to provide fifty photographs illustrating a new edition of Walt Whitman's *Leaves of Grass*. Again driving and camping, the Westons covered 20,000 miles across America before the outbreak of World War Two interrupted their journey and sent them back to Carmel.

With the new decade, a joyous and productive period in Edward's life came gradually, then cruelly, to an end. Perhaps there were foreshadowings. Several photographs of the period revealed an uncharacteristic, unmistakably funereal quality, particularly those taken in the Deep South for *Leaves of Grass*. In retrospect, Edward felt his bond with Charis had mysteriously begun to dissolve during that expedition.

Some of Edward's closest admirers were dismayed by what they perceived as satirical, even cynical, comment in his early wartime photographs, for example, a nude of Charis wearing a gas mask. He responded indignantly, claiming with justice that he had met opposition at every new turn his work had taken. Edward and Charis re-

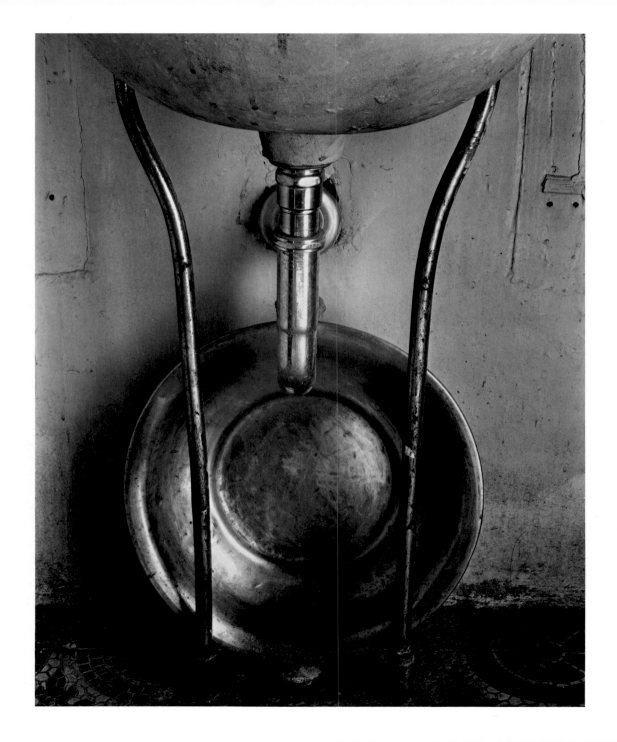

mained together until 1944, then separated and later divorced. It was a shock for their friends and family—the end of Camelot on Wildcat Hill.

In 1946, Edward's longtime friend, Nancy Newhall, curated a massive Edward Weston retrospective—350 prints—at the Museum of Modern Art. Edward had asked his youngest son, Cole, to meet him in New York. "He looked very frail," Cole later wrote, "nothing like the physical fitness buff who could beat all four sons in the 100-yard dash till he was past forty." The reason was soon clear: Edward was ill with Parkinson's disease.

The disease progressed slowly, inexorably taking away Edward's power to control his speech and movements. The cruel irony was that his mind remained sharp, his artist's vision powerful—trapped within a body that could serve neither. Brett, already established in his own right as a leading art photographer, and Cole, whose color images were widely reproduced, helped Edward with major printing projects. Later, Cole would print all Edward Weston images for sale. Two years after the MOMA retrospective, Edward went to Point Lobos and made the last photograph of his life, "Rocks and Pebbles, 1948."

He was to live ten years longer. In 1958, Edward struggled from his bed, sat in a chair facing the sea, and died at dawn on New Year's Day.

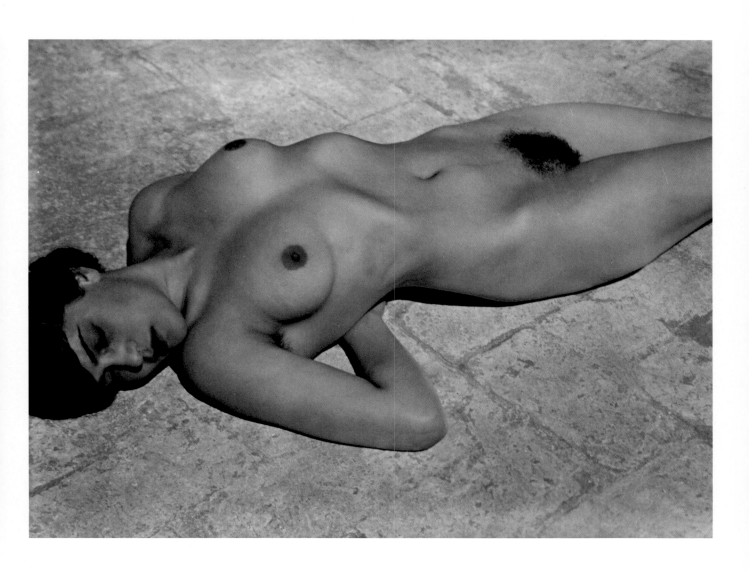

Success in photography, portraiture especially, is dependent on being able to grasp those supreme instants which pass with the ticking of a clock, never to be duplicated—so light, balance—expression must be seen—felt as it were—in a flash, the mechanics and technique being so perfected in one as to be absolutely automatic.

1922

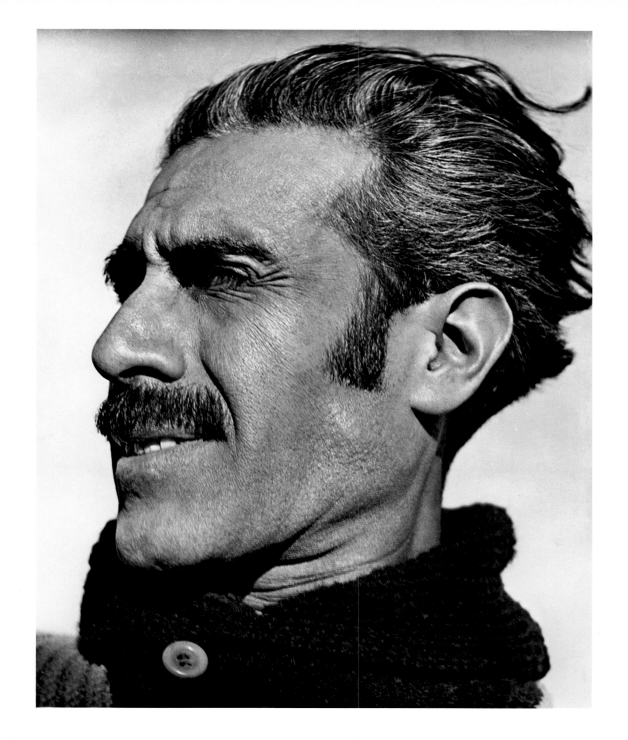

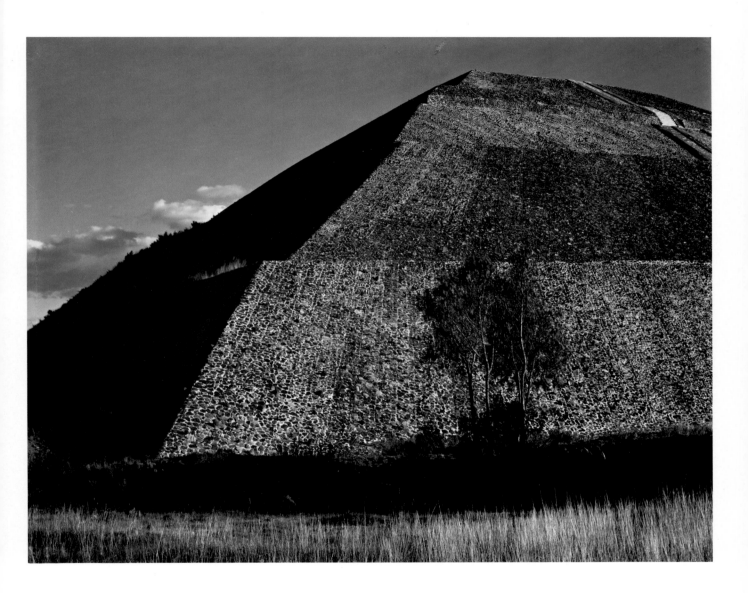

It is classic, completely satisfying,—a pepper—but more than a pepper: abstract, in that it is completely outside subject matter. It has no psychological attributes, no human emotions are aroused, this new pepper takes one beyond the world we know in the conscious mind. To be sure much of my work has this quality, many of my last year's peppers, but this one, and in fact all the new ones, take one into an inner reality—the absolute—with clear understanding, a mystic revealment. This is the "significant presentation" that I mean, the presentation through one's intuitive self, seeing "through one's eyes, not with them"; the visionary.

1930

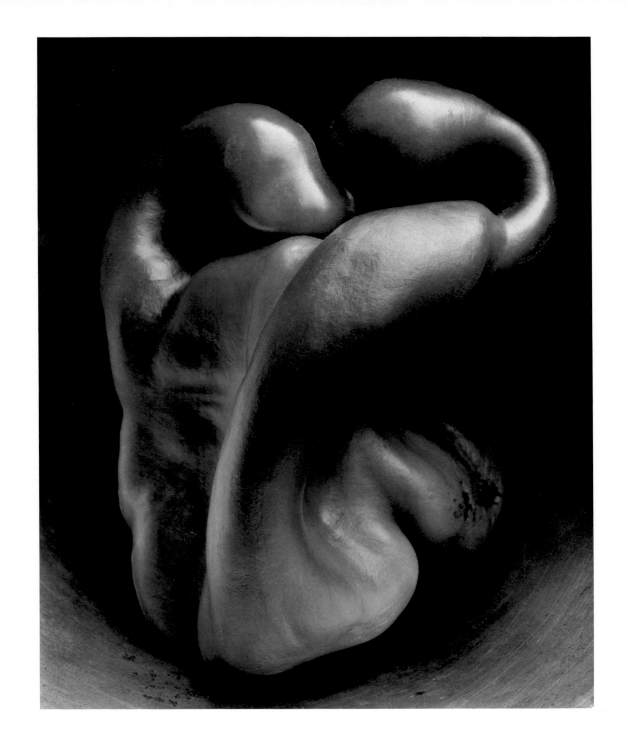

29

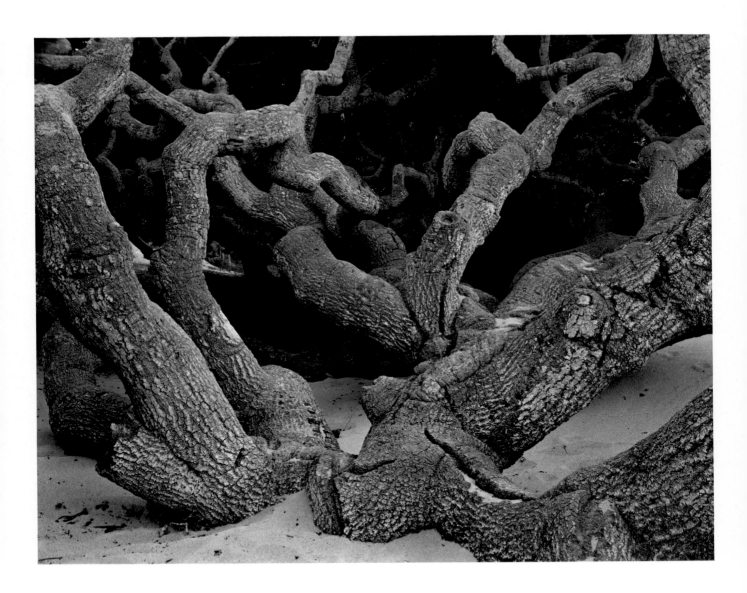

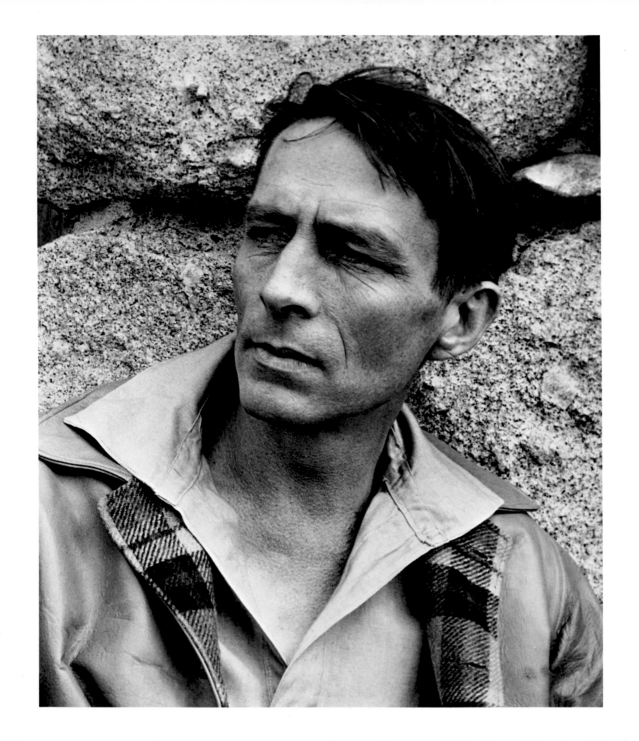

33

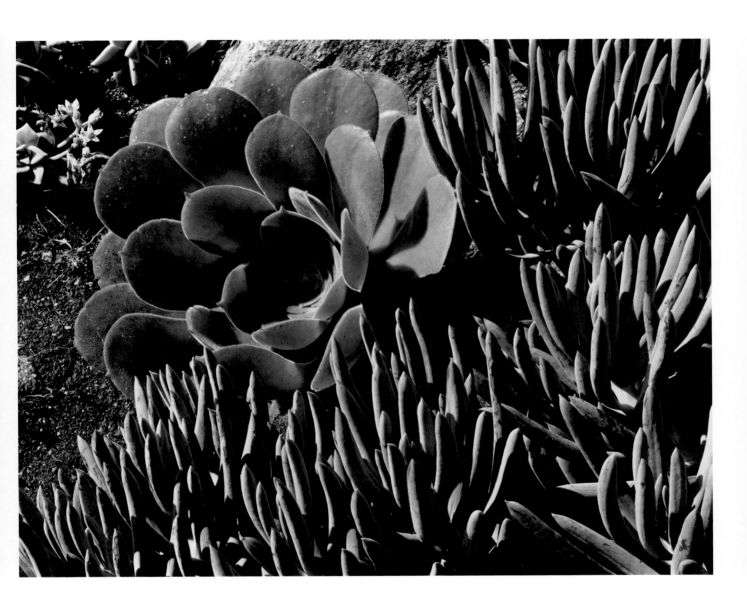

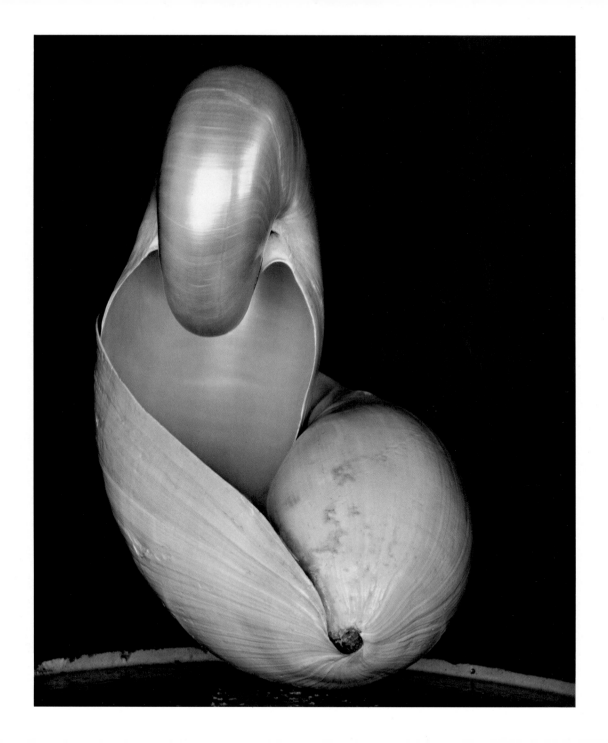

37

I never try to limit myself by theories. I do not question right or wrong approach when I am interested or amazed,—impelled to work. I do not fear logic, I dare to be irrational, or really never consider whether I am or not. This keeps me fluid, open to fresh impulse, free from formulae—the public who know my work is often surprised, the critics, who all, or most of them, have their pet formulae are disturbed, and my friends distressed.

1932

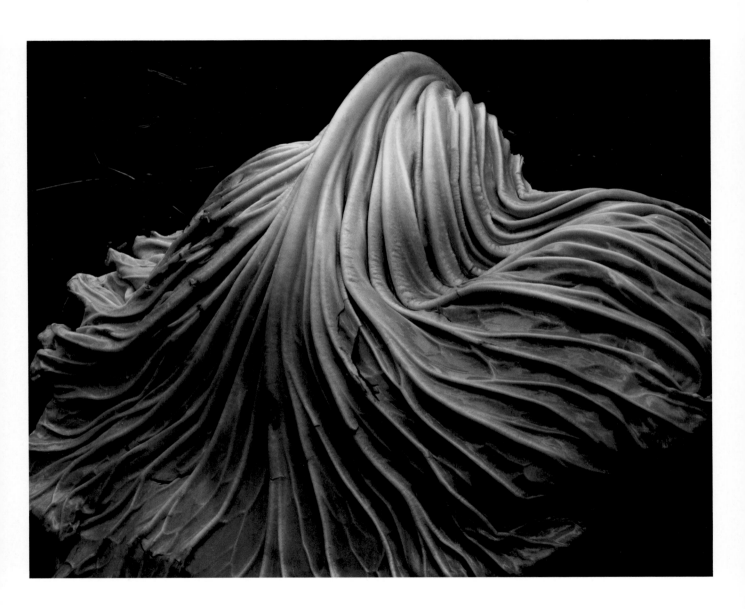

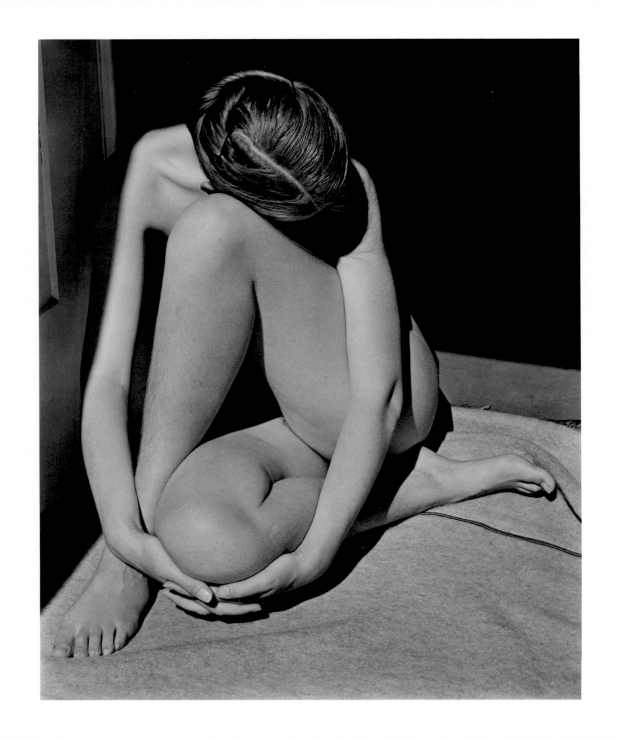

Photography is not at all seeing in the sense that the eye sees. . . . Our vision is in a constant state of flux, while the camera captures and fixes forever a single, isolated, condition of the moment.

1932

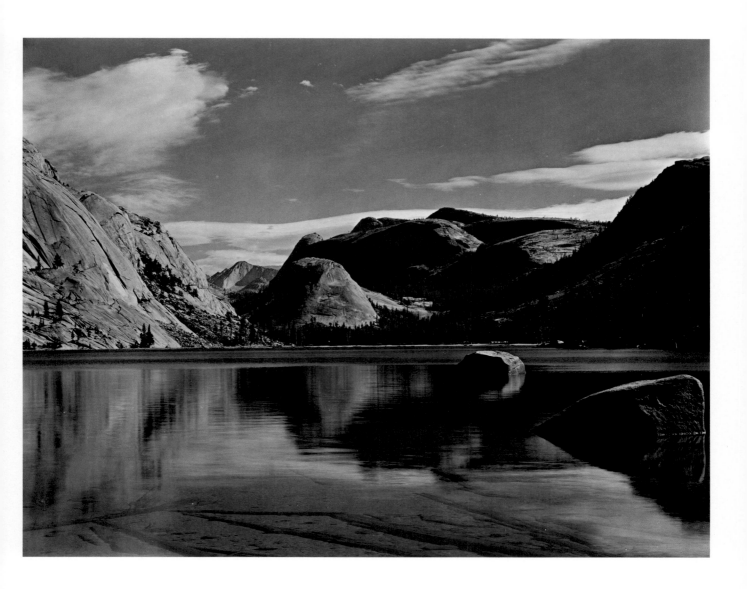

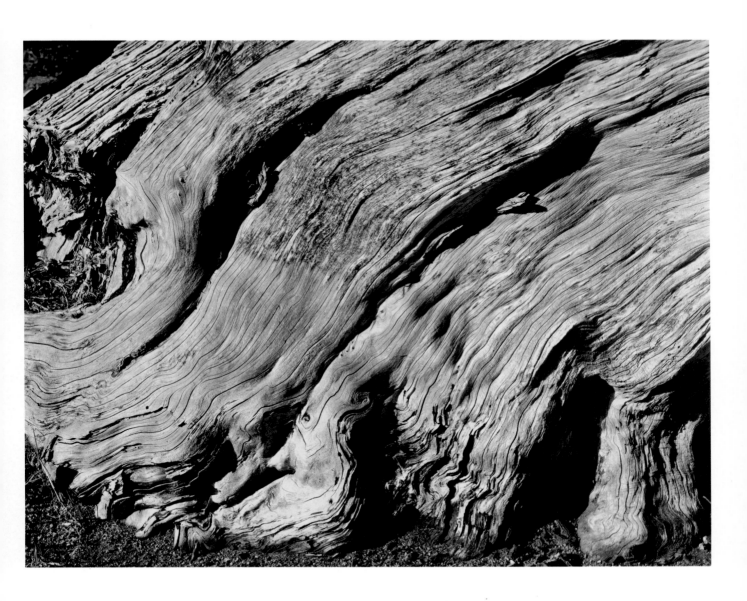

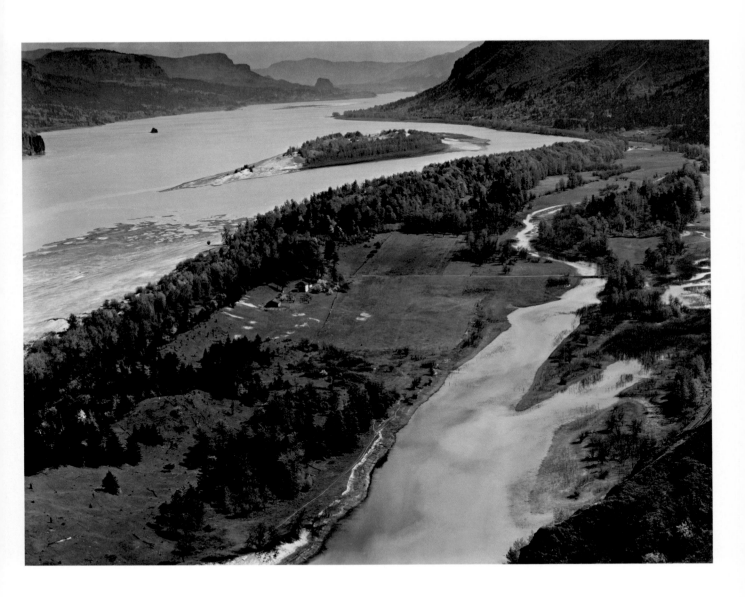

It seems so utterly naive that landscape—not that of the pictorial school—is not considered of "social significance" when it has a far more important bearing on the human race of a given locale than excrescences called cities. By landscape, I mean every physical aspect of a given region—weather, soil, wildflowers, mountain peaks— and its effect on the psyche and physical appearance of the people. My landscapes of the past year are years in advance of any I have done before of any I have seen.

1938

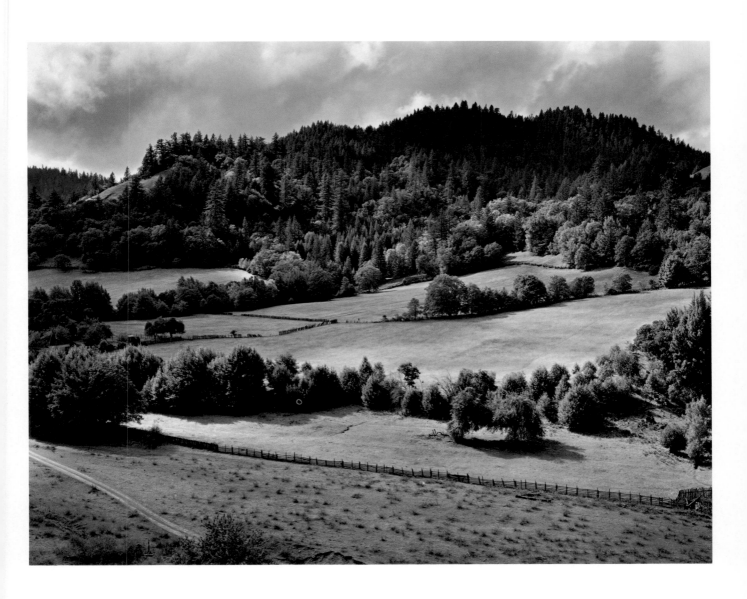

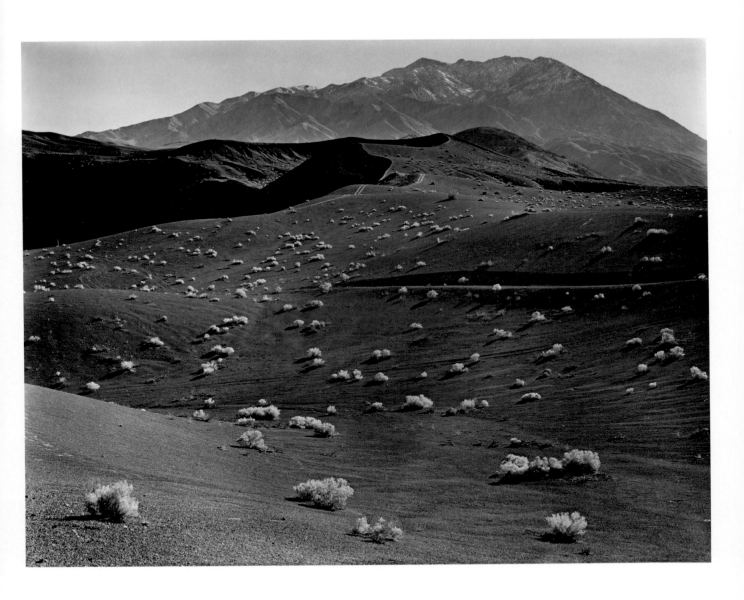

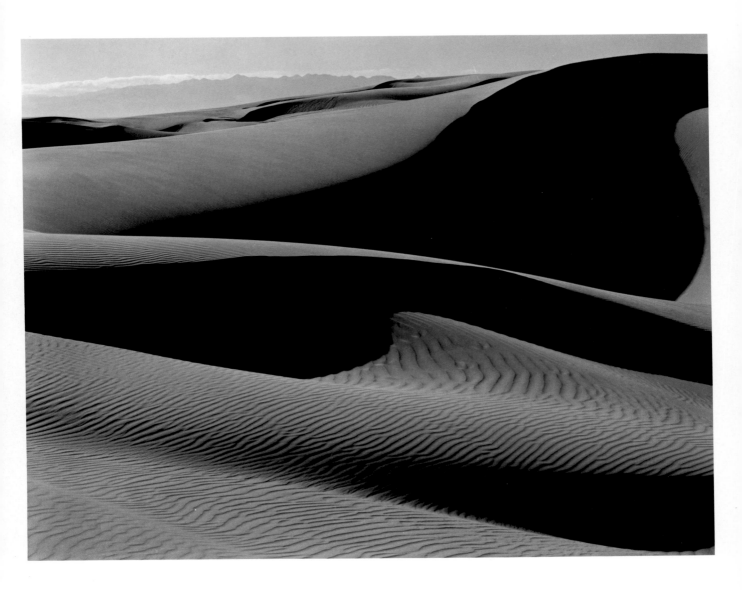

And what does anyone know of my past year's work?
1300 negatives,—21,000 miles of searching. No, I have
not done "faces and postures," except one dead man (wish
I could have found more) and many dead animals; but
I have done ruins and wreckage by the square mile and
square inch, and some satires.

1938

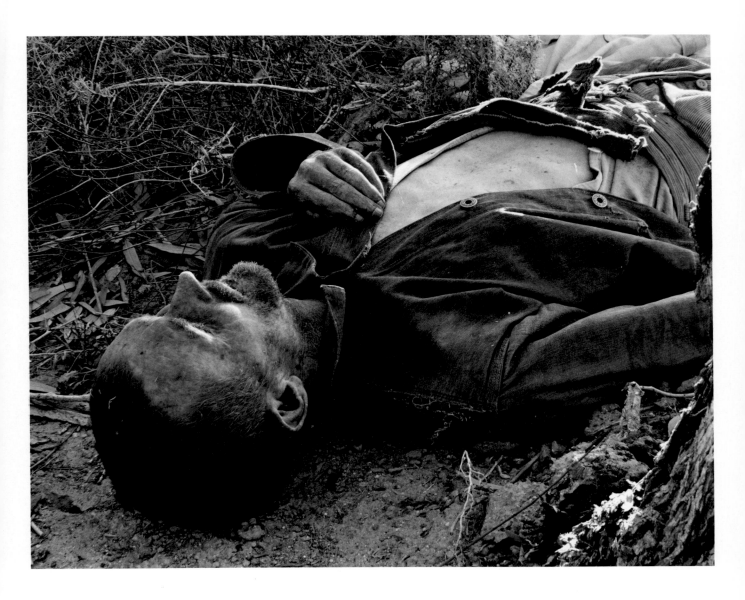

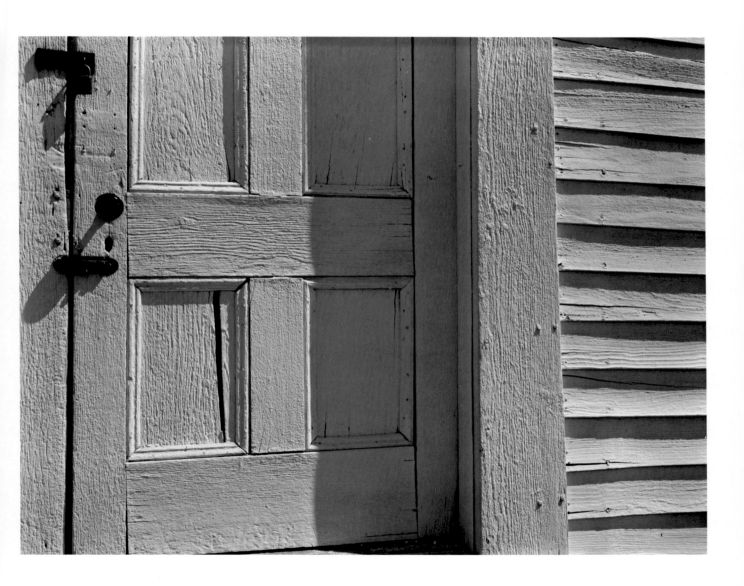

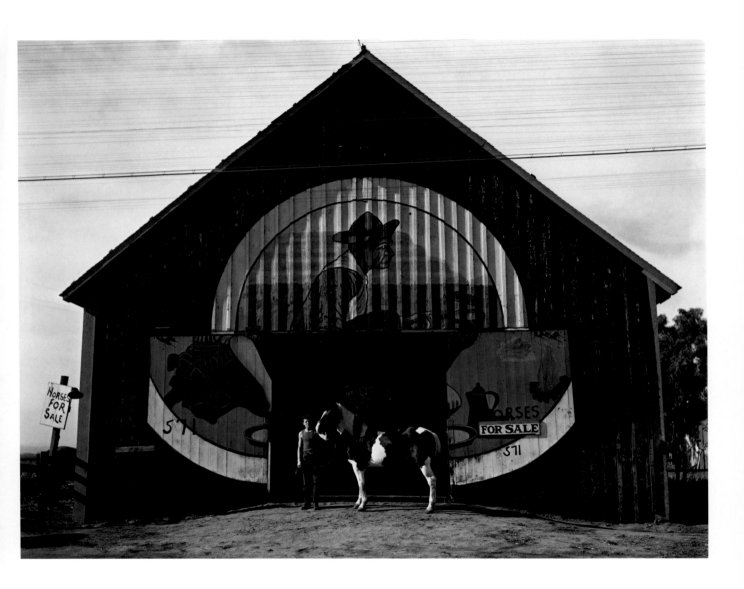

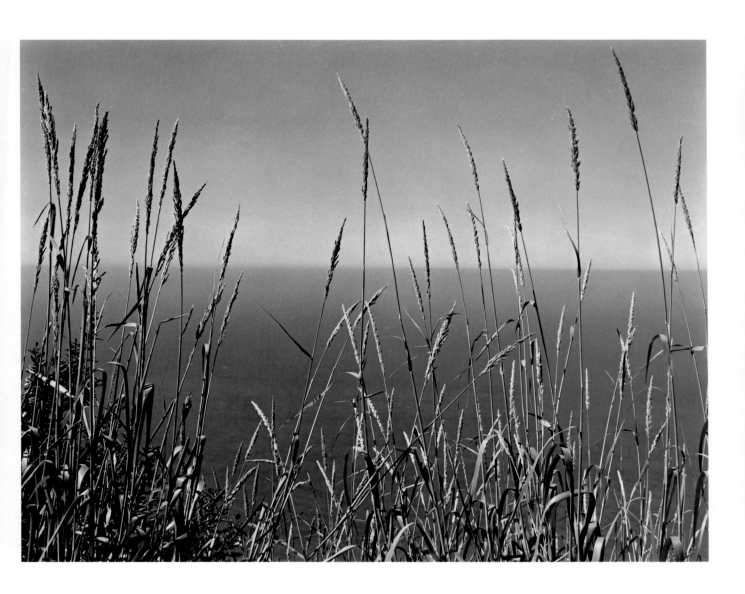

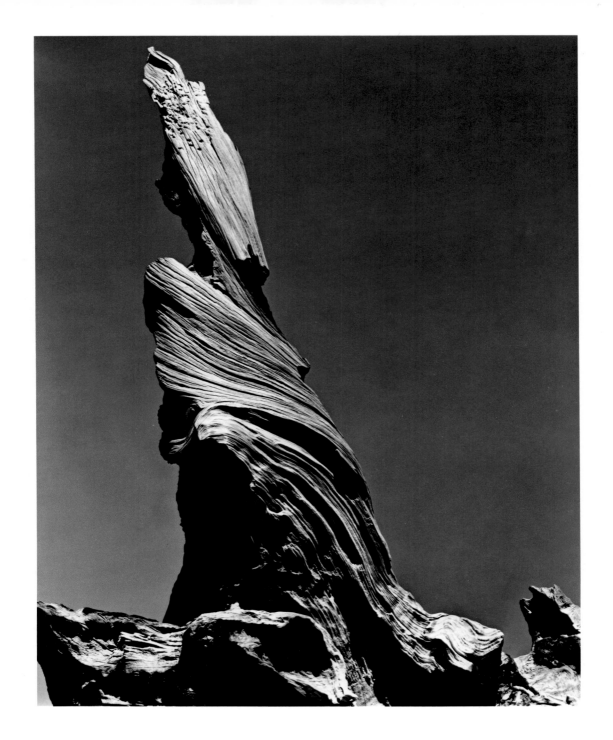

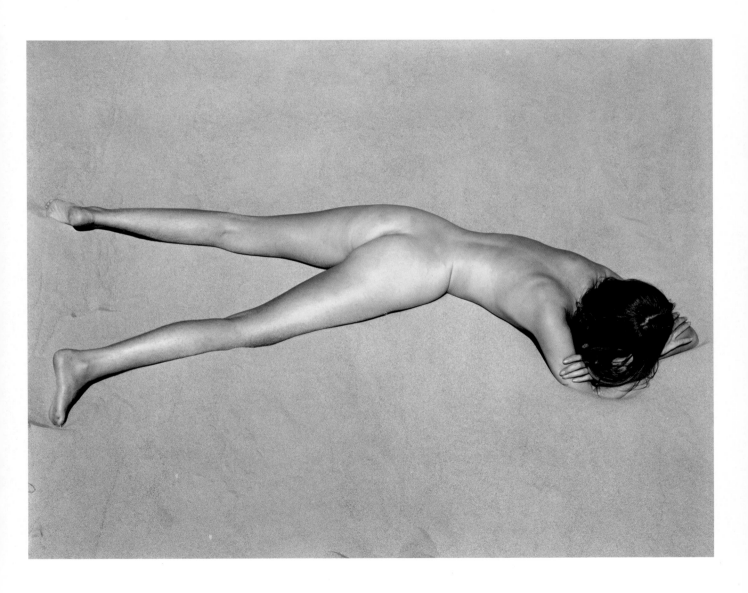

I get a greater joy from finding things in Nature, already composed, than I do from my finest personal arrangements. After all, selection is another way of arranging: to move the camera an eighth of an inch is quite as subtle as moving likewise a pepper.

1930

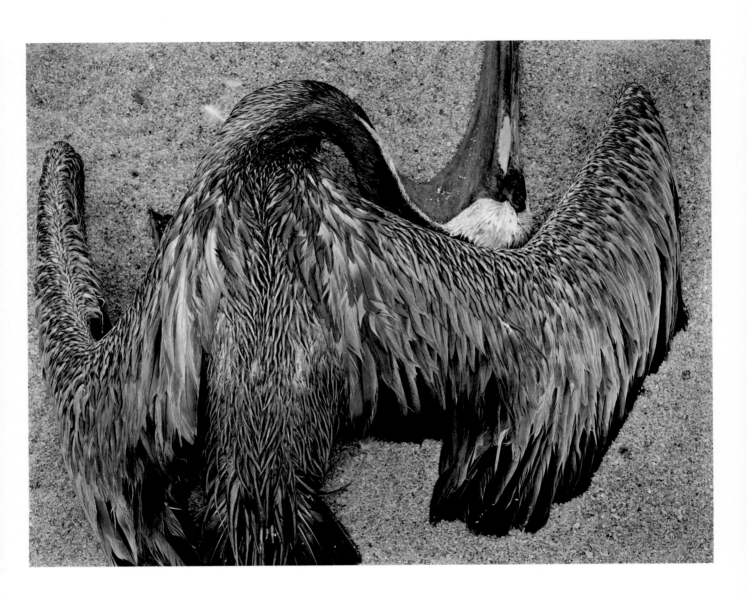

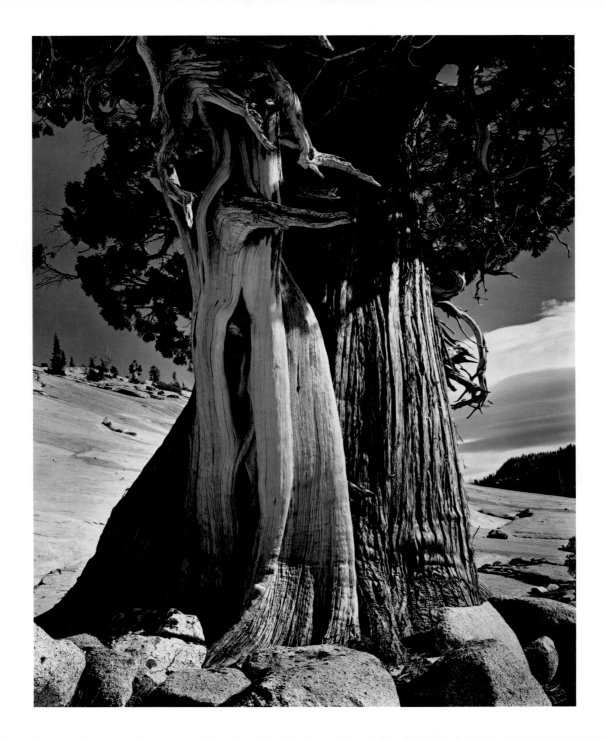

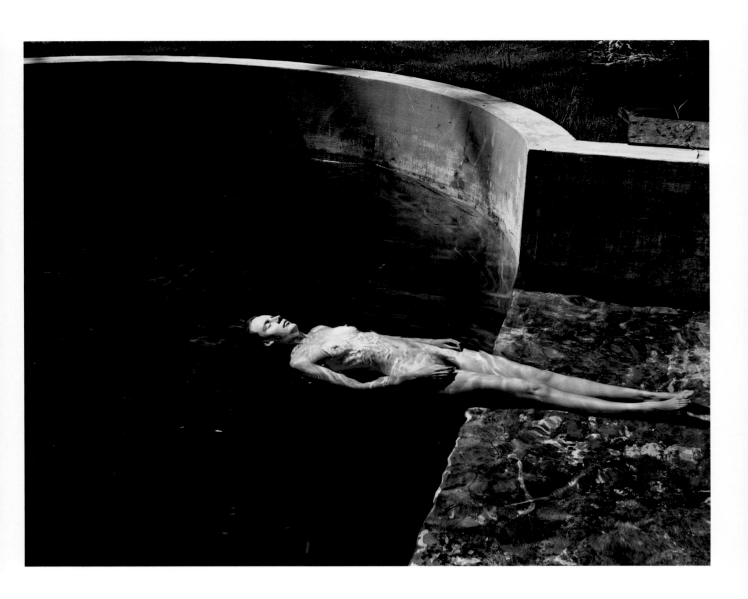

On accepting a commission to illustrate Walt Whitman's *Leaves of Grass*.

I have thought over the subject pro and con, questioned "am I the one to do this?" This should tell you; there will be no attempt to "illustrate," no symbolism except perhaps in a very broad sense, no effort to recapture Whitman's day. The reproductions, only 54, will have no titles, no captions. This leaves me great freedom— I can use anything from an airplane to a longshoreman. I do believe, with Guggenheim experience, I can and will do the best work of my life. Of course I will never please everyone with my America—wouldn't try to.

April 28, 1941

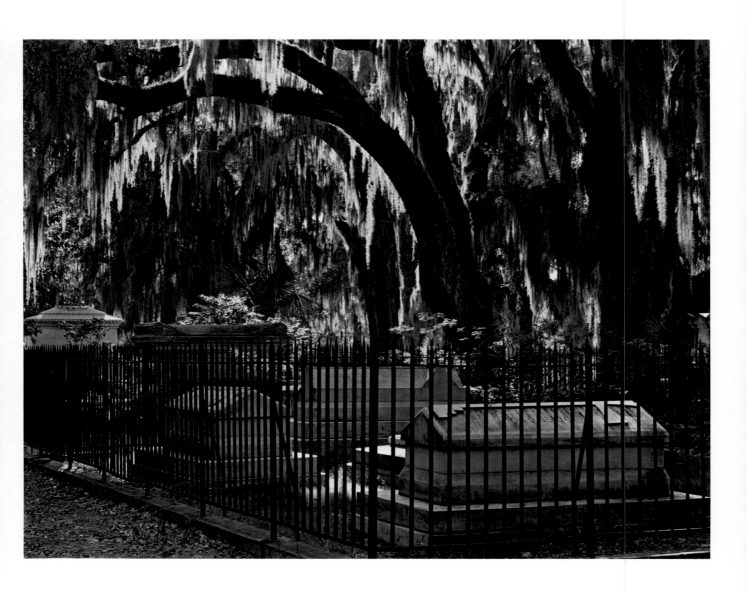

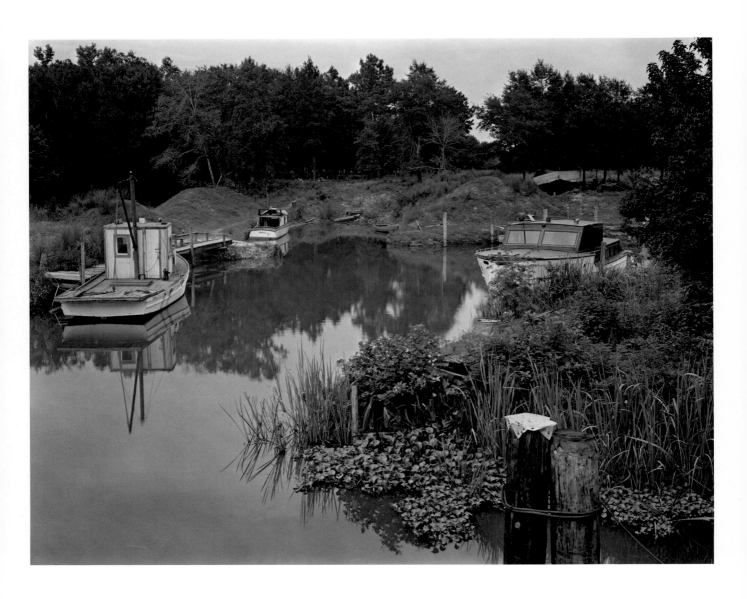

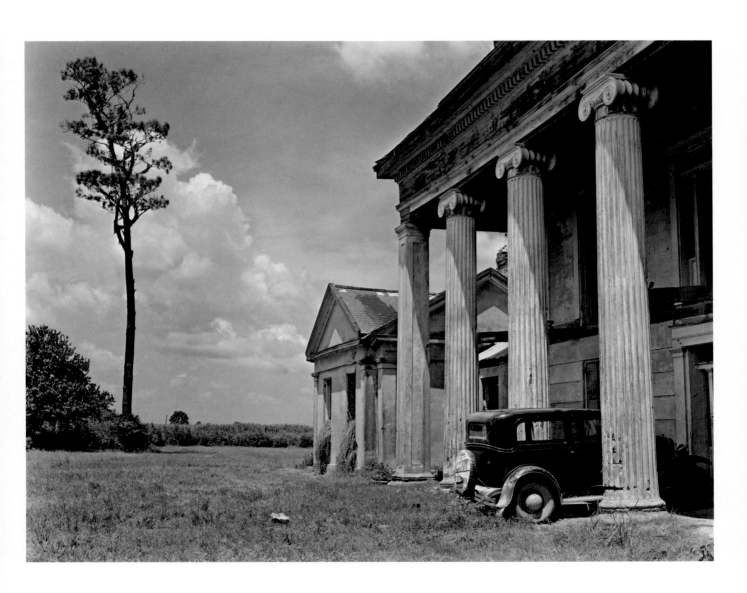

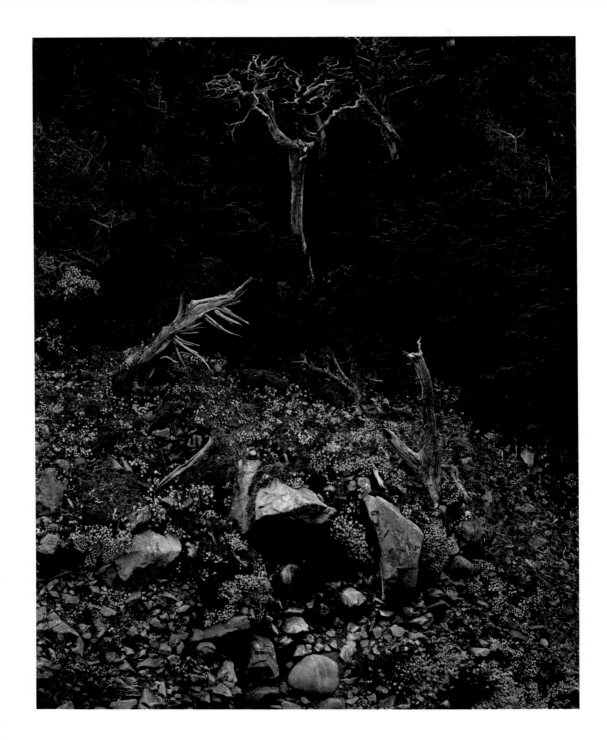

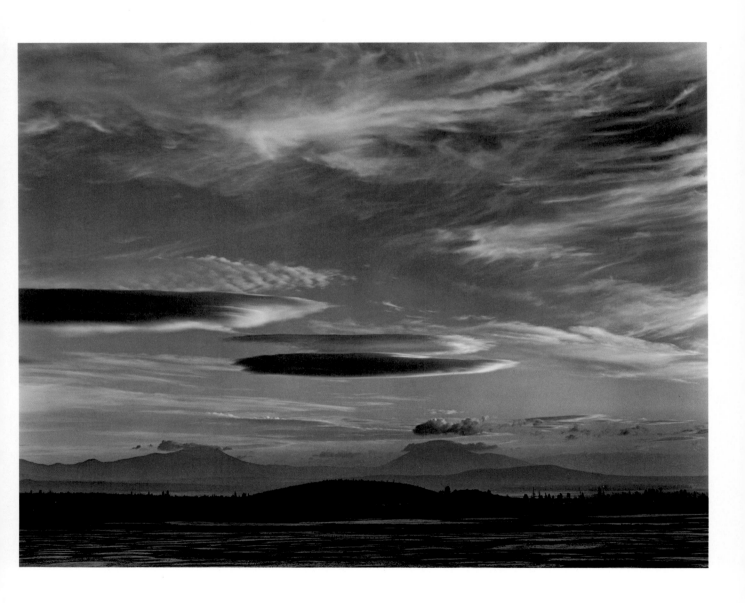

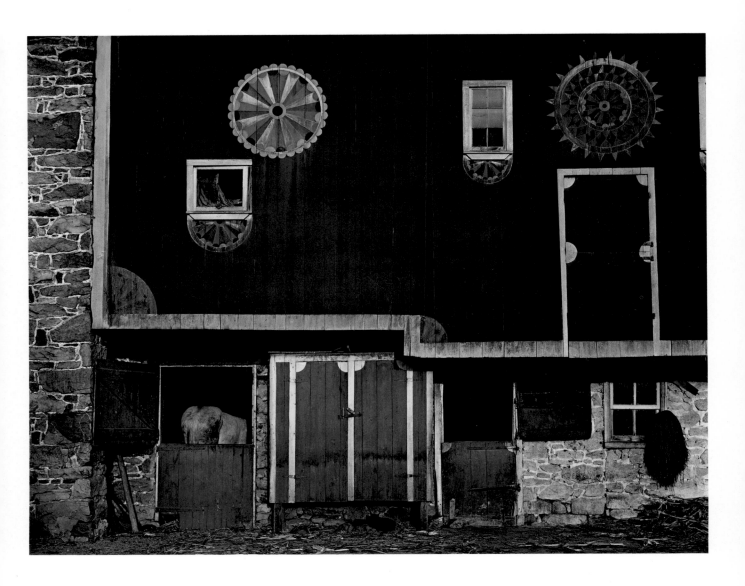

The answer comes always more clearly after seeing great work of the sculptor or painter, past or present, work based on conventionalized nature, superb forms, decorative motives. That the approach to photography must be through another avenue, that the camera should be used for a recording of life, for rendering the very substance and quintessence of the thing itself, whether it be polished steel or palpitating flesh.

1925

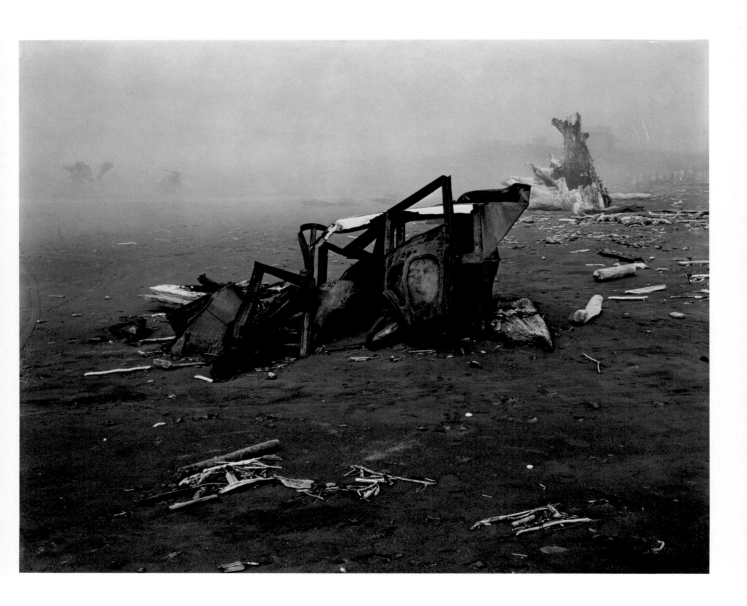

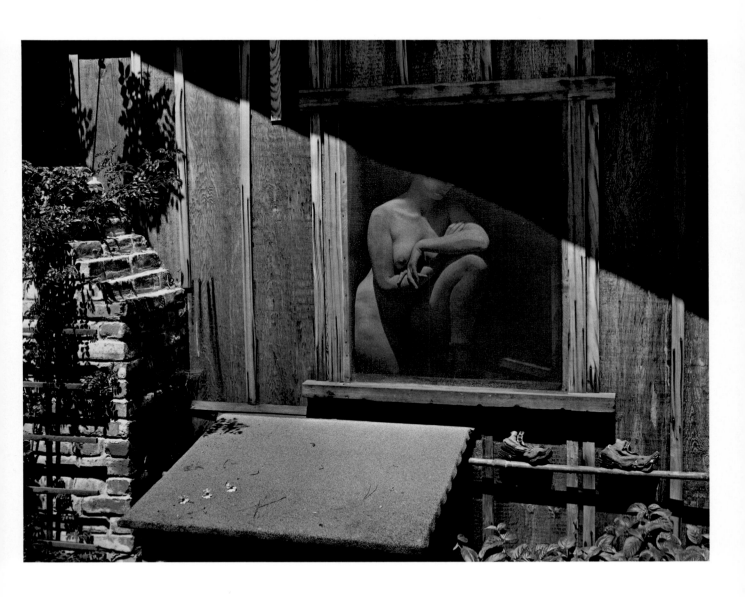

The camera can only record what is before it, so I must await and be able to grasp the right moment when it is presented on my ground glass. In portraiture, figures, clouds,—trying to record ever changing movement and expression, everything depends upon my clear visions, my intuition at the important instant, which if lost can never be repeated.

1927

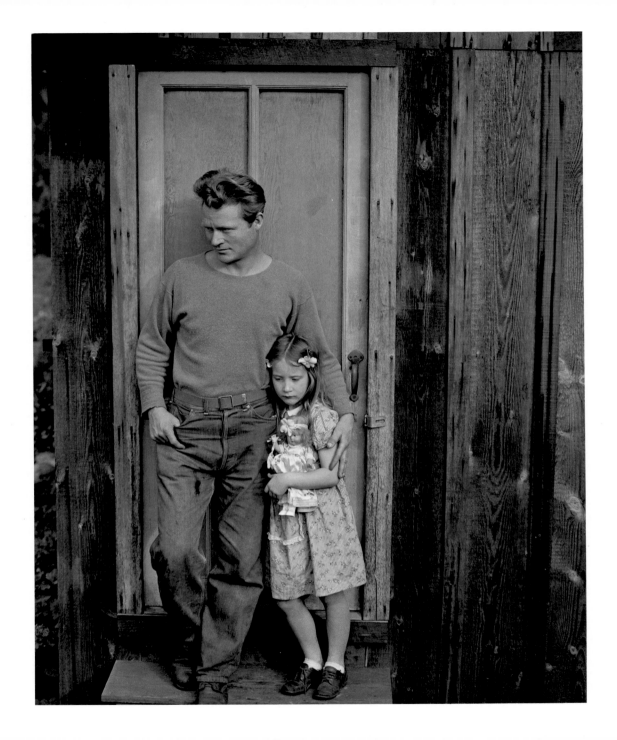

PHOTOGRAPHS

Front cover: Maguey Cactus, Mexico, 1926
Frontispiece: Shell, 1924

7.	Armco Steel, Ohio, 1922
9.	Neil, 1925
11.	Ramiel in Attic, 1920
13.	Breast, 1920
15.	Plaster Works, Los Angeles, 1925
17.	Tina, 1924
19.	Taos Pueblo, New Mexico, 1933
21.	Washbowl, 1926
23.	Nude, 1923
25.	Manuel Hernández Galván, Mexico, 1924
27.	Piramide del Sol, Mexico, 1923
29.	Pepper, 1930
31.	Oak, Monterey County, 1929
33.	Robinson Jeffers, Ton House, 1929
35.	Succulent, 1930
37.	Shells, 1927
39.	Cabbage Leaf, 1931
41.	Nude, 1936
43.	Tenaya Lake, 1937
45.	Cypress, Point Lobos, 1929

47. Dante's View, 1938
49. Eel River Ranch, 1937
51. Ubehebe Crater area, Death Valley, 1938
53. Oceano, 1936
55. Dead Man, Colorado Desert, 1938
57. Church Door, Horitos, 1940
59. Salinas, 1939
61. Grass Against Sea, 1937
63. Driftwood Stump, 1937
65. Nude, 1936
67. Pelican, Point Lobos, 1942
69. Juniper at Lake Tenaya, 1937
71. Nude Floating, 1939
73. Bonaventure Cemetery, Savannah, 1941
75. Contraband Bayou, Louisiana, 1941
77. Woodlawn Plantation, Louisiana, 1941
79. Point Lobos, 1945
81. Lassen National Park, 1937
83. Pennsylvania Dutch Barn, 1941
85. Wrecked Car, Crescent Beach, 1939
87. Spring, 1943
89. Brett and Erica Weston, 1945
95. China Grove, Point Lobos, 1940
Back cover: Edward Weston by Cole Weston

BRIEF CHRONOLOGY

1886 Born, Edward Henry Weston, March 24, to Edward Burbank Weston and Alice Jeanette Brett, in Highland Park, Illinois.

1902 Begins to photograph, with Bulls-Eye #2 camera, a present from his father. He soon purchases a 5 × 7 camera and tripod.

1903 Graduates Oakland Grammar School; works for Marshall Field & Co., Chicago, three years. Continues to photograph; sees his first photography exhibit, work from the Chicago Photographic exhibit, at the Art Institute of Chicago.

1906 Visits sister May in California; decides to stay. Works as assistant railroad surveyor in Los Angeles and Nevada. Decides to become professional photographer; begins as itinerant portraitist with a postcard camera.

1908–1911 Attends Illinois College of Photography; returns to Los Angeles and works as a retoucher and printer for A. Mojonier Studio.

1909 Marries Flora May Chandler. Four sons: Chandler, 1910; Brett, 1911; Neil, 1914; Cole, 1919.

1911 Opens own studio in Tropico (now Glendale), California. Works in soft-focus, pictorial style.

1914–1917 Commercial and critical success; receives awards and prizes (in pictorial salons with Japanese and Whistlerian motifs); demonstrates techniques to professional societies; elected member to London Salon of Photography in 1917. Many one-man shows. Exhibits photographs at Panama-Pacific International Exposition, 1915.

1919–1921 Ceases to exhibit commercial and pictorial work. Begins to experiment with abstract motifs and sharp-focus style; unusual angles and lighting; fragments of faces and nudes. Exhibits at Shaku-Do-Sha Gallery, Los Angeles, and at California Camera Club, San Francisco. Meets Tina Modotti.

1922–1923 One-man show at Academia de Bellas Artes in Mexico City. Visits May in Middletown, Ohio, where he photographs Armco Steelworks. These photographs become turning point and thereafter he works only in sharp-focus style. Travels to New York; meets Alfred Stieglitz, Paul Strand, Charles Sheeler.

1923 Moves to Mexico City with Tina Modotti and

Chandler where they live until 1926; opens portrait studio, first in Tacubaya, then Mexico City. Meets Diego Rivera, Frieda Kahlo, Alfaro Siqueiros. José Clemente Orozco, Jean Charlot, and others. Concentrates on outdoor portraits, nudes, still-life close-ups of Mexican folk art.

1924–1925 Work begins to reflect subjects that will become increasingly important: close-ups of vegetables, shells, trees, rocks, and clouds.

1925 Returns to California for eight months; shares portrait studio with Johan Hagemeyer. Shoots industrials; 8 × 10 unposed portraits.

1926 Back in Mexico, he travels through country with Tina and Brett; photographs sculpture on commission; markets, landscapes, clouds, and other series for himself.

1927 Returns to Glendale. Begins series of extreme close-ups of shells, vegetables.

1928 Begins California series: Mojave Desert, trees. Opens portrait studio in San Francisco with Brett.

1929 1929–1935 lives in Carmel, where studio is located. First Point Lobos series: close-ups of cypresses, rocks, kelp. Continues studio work with vegetables. Contributes foreword, organizes American film and photo section, and exhibits at *"Deutsche Werkbund"* exhibition, Stuttgart.

1930 First one-man show in New York, at Delphic Studios.

1932 f-64 group organized with Ansel Adams, Imogen Cunningham, Willard Van Dyke, John Paul Edwards, Sonya Noskowiak and Henry Swift. First group exhibit at M. H. de Young Museum, San Francisco.

1933 Photographs landscapes, clouds, architecture in New Mexico and Monterey area.

1934 Photographs sand dunes at Oceano, California with Brett; begins series of nudes of Charis Wilson. Works briefly for U.S. Government's Works Progress Administration.

1935 Moves to Santa Monica from Carmel with Brett.

1936 Continues work on dunes, nudes at Oceano.

1937 Four prints of the Oceano dunes series in *Photography 1839-1937* exhibit curated by Beaumont Newhall at

Museum of Modern Art, New York. Divorces Flora. Awarded first Solomon R. Guggenheim Fellowship for a photographer. Travels with Charis Wilson in California, Arizona, Nevada, Oregon, New Mexico, Washington.

1938 Fellowship extended. Marries Charis. Returns to house on Wildcat Hill in Carmel, built by son Neil. Prints from 1500 negatives from Guggenheim Project.

1939 New Point Lobos series and 8 × 10 portraits in landscape series.

1940 *California and the West* with photographs from Guggenheim travels, and with text by Charis published by Duell, Sloan & Pearce.

1941 Travels through South and East working on illustrations for special edition of *Leaves of Grass*. With attack on Pearl Harbor, returns to Carmel; serves as air-raid plane spotter at Point Lobos.

1942–1945 Defense activities. Photographs in backyard: cats, portraits, nudes in landscape. Charis divorces him. Early signs of Parkinson's disease.

1946 Major retrospective exhibit at Museum of Modern Art, New York, which publishes a monograph of his work.

1947 Experiments at Point Lobos with color photography for Kodak. Travels with Willard Van Dyke as subject for his film, *The Photographer*.

1948–1958 Last photographs at Point Lobos. With the increasing severity of his illness, Weston is limited to supervising Brett, Cole, and Dody Warren's printing of his negatives.

1950 Retrospective at *Musée d'Art Moderne, Paris.*

1951 Named honorary Member of the American Photographic Society.

1952 With Brett's help, produces *Fiftieth Anniversary Portfolio.*

1955 Eight sets of 838 prints made from negatives selected as the best of his life's work. The portfolios, made with Brett's help are entitled *Project Print*.

1956 "The World of Edward Weston," curated by Nancy and Beaumont Newhall, Smithsonian Institution.

1958 Dies, January 1, at home on Wildcat Hill.

EXHIBITIONS

Individual Exhibitions

1919 Shaku-Do-Sha, Los Angeles.

1921 California Camera Club, San Francisco.

1922 Academia de Bellas Artes, Mexico City.

1923 Aztec Land Gallery, Mexico City.

1924 Aztec Land Gallery, Mexico City (with Tina Modotti).

1925 Museo del Estado, Guadalajara, Mexico (with Tina Modotti).

1926 Salon de Arte, Mexico City (with Tina Modotti).

1927 Los Angeles Museum (with Brett Weston).

1930 Delphic Studios, New York.

1931 Denny Watrous Gallery, Carmel, CA.
M. H. de Young Memorial Museum, San Francisco.

1932 Delphic Studios, New York.

1933 Dayton Art Institute, Ohio.

1937 Nierendorf Gallery, New York.

1946 Museum of Modern Art, New York (retrospective).

1950 Musée d'Art Moderne, Paris (retrospective).

1951 *Edward Weston: 50 Photos,* American Society of Photographers, New York.

1956 Smithsonian Institution, Washington, D.C.

1960 Limelight Gallery, New York.

1962 Staatliche Landesbildstelle, Hamburg.

1963 Carl Siembab Gallery, Boston.

1965 *The Heritage of Edward Weston,* University of Oregon, Eugene.

1966 International Museum of Photography at George Eastman House, Rochester, NY.

Washington Gallery of Modern Art, Washington, D.C. (traveled to the University of Texas at Austin, and the University of Oregon, Eugene).

Museo de Arte Moderno, Mexico City (with Brett Weston).

1968 Carl Siembab Gallery, Boston.

1969 Witkin Gallery, New York.

1970 Metropolitan Museum of Art, New York.

1971 International Museum of Photography, George Eastman House, Rochester, NY.

1972 Metropolitan Museum of Art, New York.
Friends of Photography, Carmel, CA (tours sites in the United States).

1975 Museum of Modern Art, New York (retrospective).

G. Ray Hawkins Gallery, Los Angeles.

1976 Stedelijk Museum, Amsterdam.

1977 Hayward Gallery, London.

Ex Libris, New York (with Tina Modotti).

1978 *Edward Weston's Gifts to His Sister,* Dayton Art Institute, Ohio (traveled to International Center of Photography, New York).

1980 Galeria Spectrum/Canon, Zaragoza, Spain.

1981 *50 Nudi 1920–1945,* Palazzo Fortuny, Venice.

The Last Edward Weston Show, Witkin Gallery, New York.

Selected Group Exhibitions
1929 *Film und Foto,* Deutscher Werkbund, Stuttgart.

1933 *Group f-64,* Ansel Adams Gallery, San Francisco.

1963 *The Photographer and the American Landscape,* Museum of Modern Art, New York.

1967 *Photography in the 20th Century,* National Gallery of Canada, Ottowa (toured Canada and the United States 1967–1973).

1975 *The Land: 20th Century Landscape Photographs Selected by Bill Brandt,* Victoria and Albert Museum, London.

1979 *Photography Rediscovered: American Photography 1900–1930,* Whitney Museum, New York.

1980 *Old and Modern Masters of Photography* Victoria and Albert Museum, London.

Southern California Photography 1900–1965, Los Angeles County Museum of Art.

1981 *The Nude in Photography,* San Francisco Museum of Modern Art.

1986 *Supreme Instants,* Co-curated by Beaumont Newhall and James L. Enyeart, Center for Creative Photography, University of Arizona.

Collections
Amon Carter Museum of Western Art, Fort Worth, TX
Art Institute of Chicago
Henry E. Huntington Library, San Marino, CA
International Museum of Photography/George Eastman House, Rochester, NY
J. Paul Getty Museum, Santa Monica
Los Angeles Public Library
Museo de Arte Moderno, Mexico City
Museum of Fine Art, Houston
Museum of Modern Art, New York
New Orleans Museum of Art
Oakland Art Museum, California
University of Illinois, Krannert Art Museum, Urbana
University of New Mexico Art Museum, Albuquerque
Royal Photographic Society, London

SELECTED BIBLIOGRAPHY

Books

Adams, Ansel, ed. *My Camera on Point Lobos*. Boston: Houghton Mifflin, and Yosemite: Virginia Adams, 1950.

Armitage, Merle, ed., *The Art of Edward Weston*. New York: E. Weyhe, 1932.

Bunnell, Peter. *Edward Weston on Photography*. Salt Lake City: Peregrine Smith, 1983.

Bunnell, Peter and David Featherstone, eds. *EW: 100 Centennial Essays in Honor of Edward Weston*. Carmel: The Friends of Photography, 1986.

Conger, Amy. *Edward Weston in Mexico, 1923–1926*. Albuquerque: University of New Mexico Press, 1983.

Danly, Susan and Weston J. Naef. *Edward Weston in Los Angeles*. Malibu: The J. Paul Getty Museum, 1986.

Davis, Keith. *Edward Weston: One Hundred Photographs from the Nelson Atkins Museum of Art and the Hallmark Photographic Collection*. Kansas City: William Rockhill Nelson Trust, 1982.

Maddow, Ben. *Edward Weston: Seventy Photographs*. Millerton, N.Y.: Aperture, Boston: New York Graphic Society, 1978.

Newhall, Beaumont. *Supreme Instants: The Photography of Edward Weston*. Boston: New York Graphic Society, 1986.

Newhall, Beaumont and Amy Conger, eds. *Edward Weston Omnibus: A Critical Anthology*. Salt Lake City: Peregrine Smith, 1984.

Newhall, Nancy, ed. *The Daybooks of Edward Weston, Volume I: Mexico*. Rochester, N.Y.: George Eastman House, 1961.

Newhall, Nancy, ed. *The Daybooks of Edward Weston, Volume II: California, 1927–34*. Rochester, N.Y.: George Eastman House; New York: Horizon Press, 1966.

Newhall, Nancy, ed. *Edward Weston, Photographer: The Flame of Recognition*. Rochester, N.Y.: Aperture, 1965.

Newhall, Nancy. *The Photographs of Edward Weston*. New York: Museum of Modern Art, 1946.

Weston, Edward. *Nudes*. Remembrance by Charis Wilson. Millerton, N.Y.: Aperture, 1977.

Whitman, Walt. *Leaves of Grass*. New York: Limited Editions Club, 1942.

Wilson, Charis and Edward Weston. *California and the West*. New York: Duell, Sloan, and Pearce, 1940.

Wilson, Charis and Edward Weston. *The Cats of Wildcat Hill*. New York: Duell, Sloan, and Pearce, 1947.

Articles:

Adams, Ansel. Review of *The Art of Edward Weston*, ed. Merle Armitage. *Creative Art*, May, 1933, pp. 386–7.

"Edward Weston: Photographer." Ed. Nancy Newhall, *Aperture*, 6, No. 1 (1958). Reproductions.

Green, Jonathan. "*The Daybooks of Edward Weston: California*, Edited by Nancy Newhall." *Aperture*, 13, No. 2 (1967), pp. 118–119.

Greenburg, Clement. "Camera's Glass Eye." *The Nation*, March 6, 1946, pp. 294–296.

McBride, Henry. "Photographs That Are Different." *New York Sun*, October 22, 1930.

Miller, Arthur. "Some Photographs by Edward Weston." *Los Angeles Sunday Times*, January 21, 1927.

Newhall, Beaumont. "Edward Weston in Retrospect." *Popular Photography*, March, 1946, pp. 42–6, 144, 146.

"One Man Show at Museum of Modern Art." *New Yorker*, February 23, 1946, p. 19.

Special Weston Issue. Ed. Lew Parella. *Camera*, April, 1958, pp. 147–181.

"Stieglitz–Weston Correspondence." *Photo-Notes*, Spring, 1949, pp. 11–15.

Weston, Edward. "Color as Form." *Modern Photography*, December, 1953, pp. 54–9, 132.

Weston, Edward. Letter to Mr. Moe of the Guggenheim Foundation, dated February 7, 1937, in elaboration of his initial proposal for a grant. *The Photo-Reporter*, May, 1971.

Weston, Edward. "Photographic Art." *Encyclopedia Britannica*, 1941, Vol. 17, pp. 769–99. Revised, 1954, by Beaumont Newhall.

Weston, Edward. "Photography-Not Pictorial." *Camera Craft*, July, 1930, pp. 313–320. Reproductions. Reprinted in *Photographers on Photography*. Ed. Nathan Lyons. Englewood Cliffs, N.J.: Prentice-Hall, 1966.

Weston, Edward and Charis Wilson. "What is a Purist?" *Camera Craft*, 46 (1939), pp. 3–9.

"Weston's First Color Photos." *Life*, November 25, 1957, pp. 16–19. Reproductions.

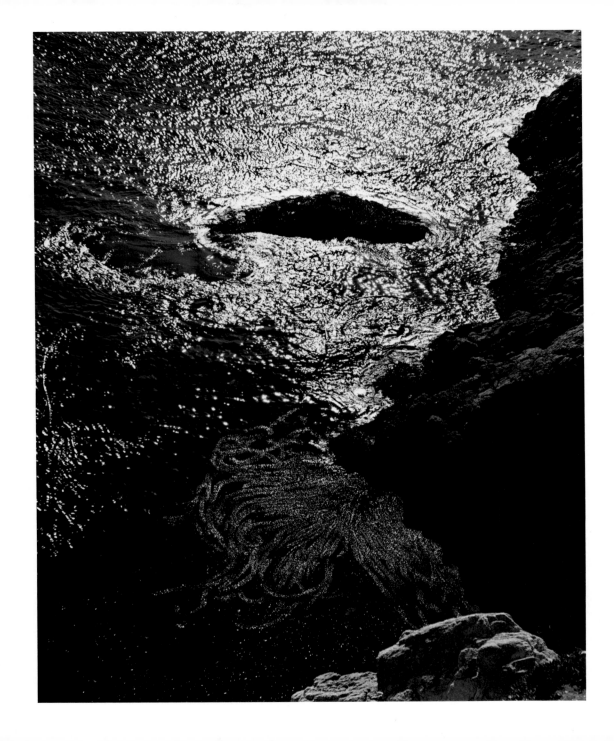